D1141444

The Littlest Book of Monet's Garden

Edited by
Janet Shirley

Ragged Bears

My garden is a slow work,
pursued with love, and
I don't deny that I'm proud of it.

Claude Monet

The weather has not been good;
ever since I came back it has been impossible
to paint outdoors, it was like winter.
So I have decided to get on with gardening
and prepare some good flower subjects
to paint in the summer, when it comes.

Claude Monet

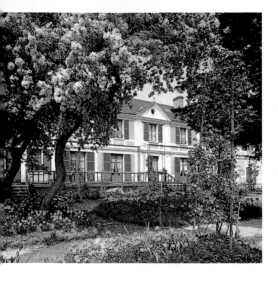

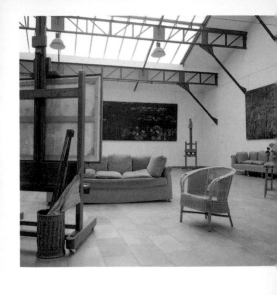

Forty years ago when I came here
there was just a farmhouse
and a small orchard
... Bit by bit I extended and organised it
... I dug, planted and weeded, and
in the evenings the children did the watering.

Claude Monet

As soon as you push open the little gate
on the main street of Giverny,
at almost any time of year,
you think you are entering paradise.

Gustave Geffroy

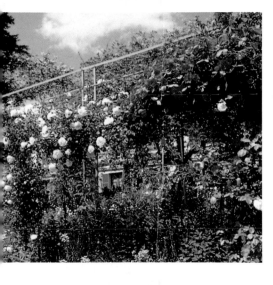

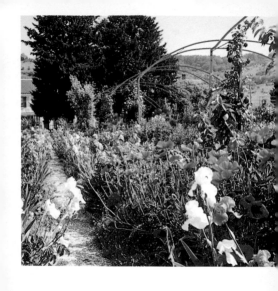

Perhaps it was flowers
that made me a painter.

Claude Monet

We'll talk gardening, as you say,
because as for art and literature,
it's all humbug.
There's nothing but the earth.

Monet's neighbour,
Octave Mirbeau

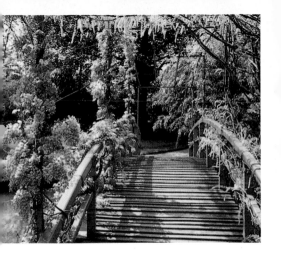

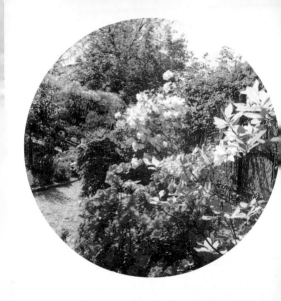

I paint as birds sing.

Claude Monet

When you go out to paint,
try to forget what it is
you've got in front of you,
a tree or a field. Just think:
here is a little square of blue,
an oblong of pink, a streak of yellow,
and paint exactly what you see.

Claude Monet

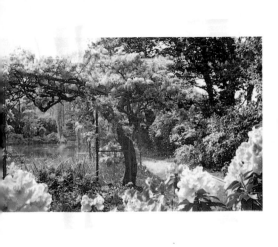

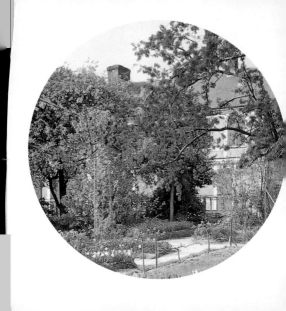

Every leaf on the tree matters as much
as the features of your model.

Claude Monet

He is an eye, that's all –
but what an eye!

Paul Cézanne

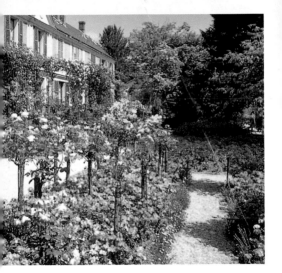

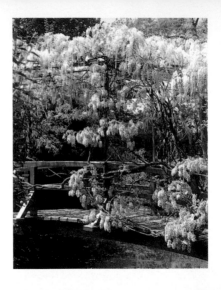

He tried to catch hold of light and
fling it onto his canvas – a crazy idea.
After a time what he was doing
was not painting any more,
he had left that behind him.

Georges Clemenceau

You are yourself,
and you have taught me
to understand light,
that's why I love you.

Georges Clemenceau

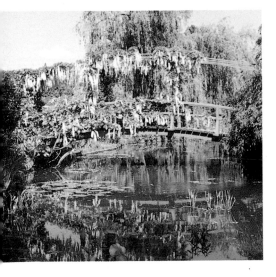

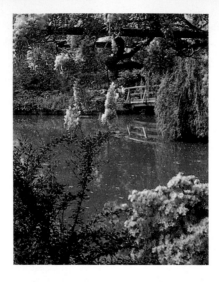

I don't want to die without
having said all I've got to say,
or at least trying to.

<div style="text-align: right">Claude Monet</div>

I am no good at anything
but painting and gardening.

Claude Monet

The Littlest Books Collection

The Littlest Christmas Book
The Littlest Easter Bunny Book
The Littlest Book Just for You
The Littlest Book for Every Day
The Littlest Book for the Heart
The Littlest Book for a Joyful Event
The Littlest Book for Mother's Day
The Littlest Book of Bears
The Littlest Book of Birds
The Littlest Book of Cats and
The Littlest Book of Gardens
The Littlest Book of Ireland
The Littlest Book of Kittens
The Littlest Book of Mice
The Littlest Book of Scotland
The Littlest Book of Small Things
The Littlest Book of Trees
The Littlest Book of Venice
The Littlest Book of the
12 Days of Christmas

Reprint 1992

© 1991 ars edition, CH-6301 Zug in association with
Ragged Bears Ltd., Andover, Hampshire
Photographs © 1991 Ed Art Lys, Versailles
All rights reserved · Printed in Germany
ISBN 1 870817 79 6